# ANIMAINEIA

## by  Zach Lipman

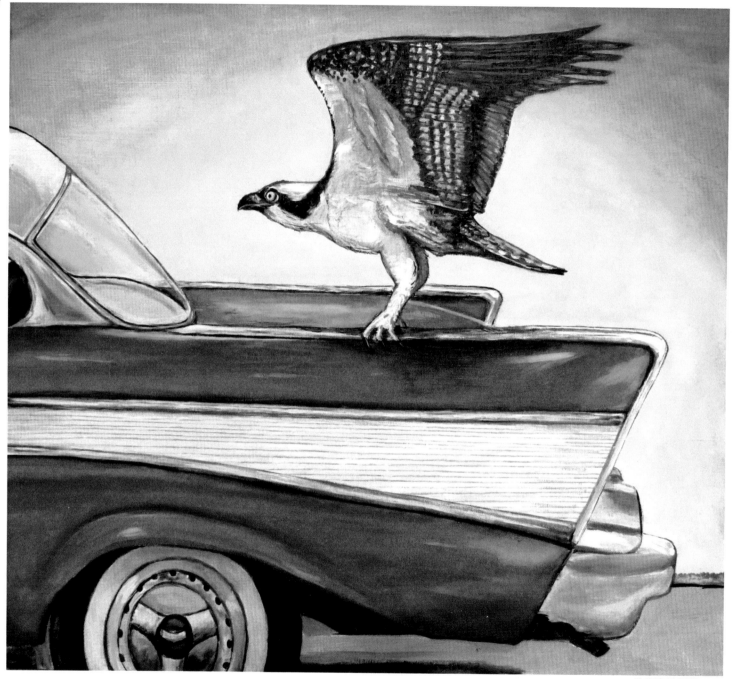

osprey

A is for absolutely aerodynamic

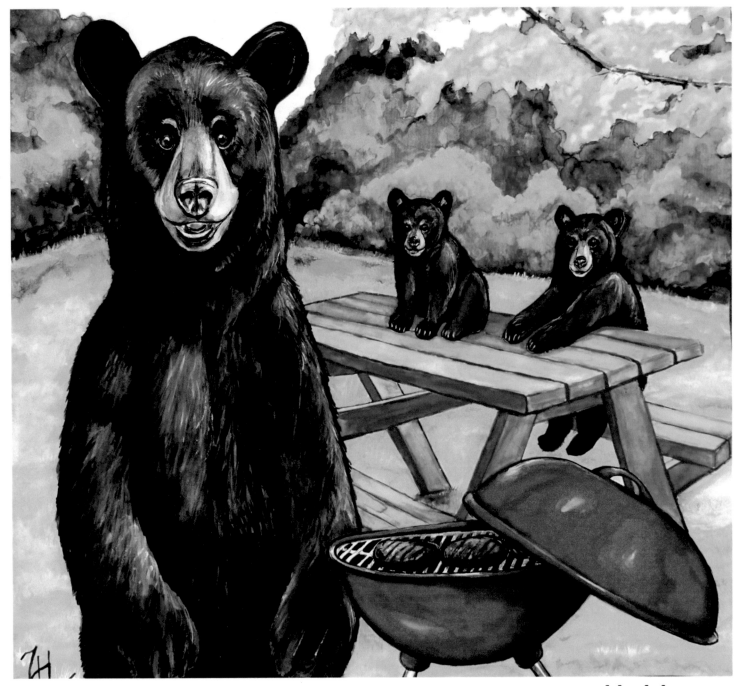

black bears

B is for backyard barbecue

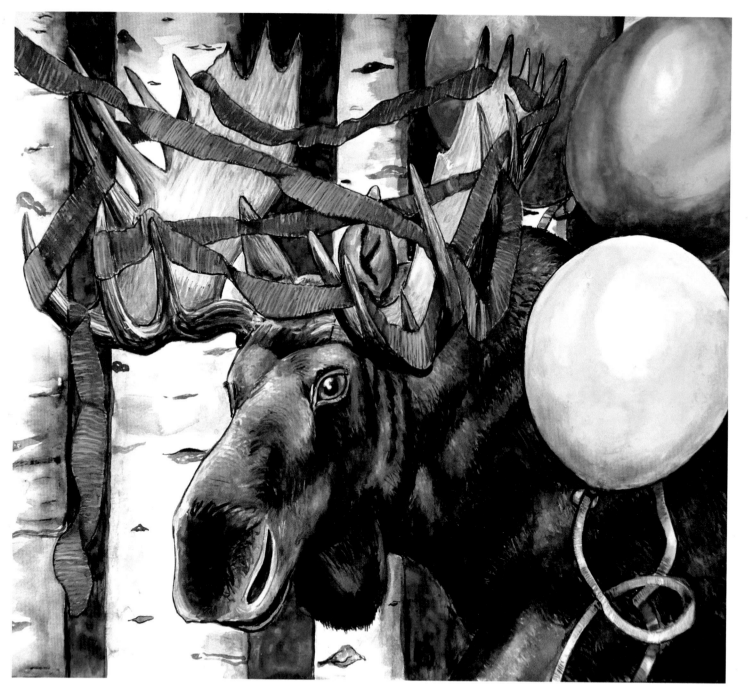

C  is for clumsy celebration

moose

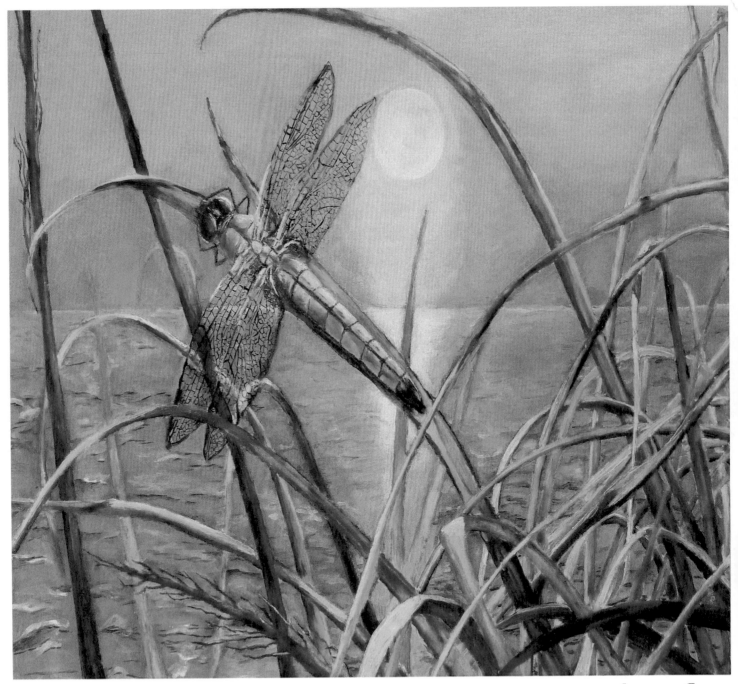

dragonfly

D is for delicate daybreak

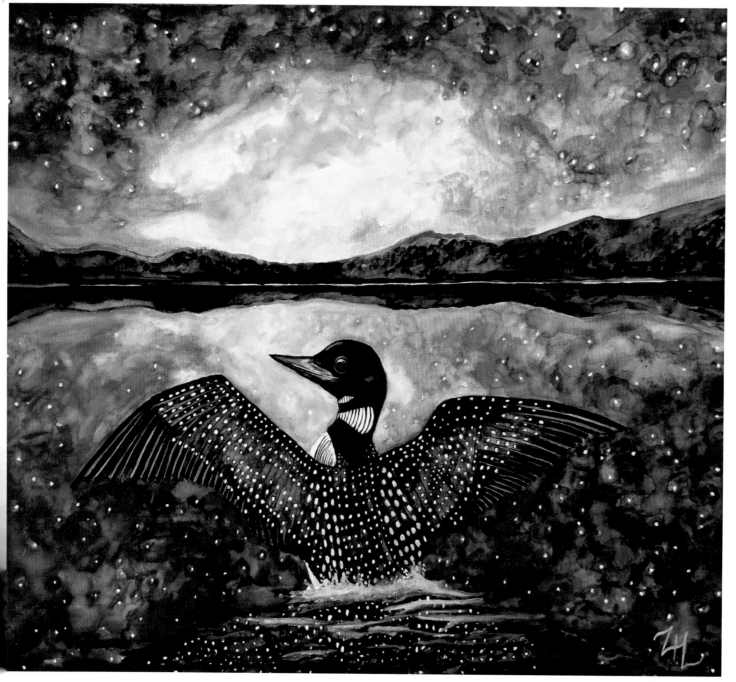

loon

E  is for ethereal enlightenment

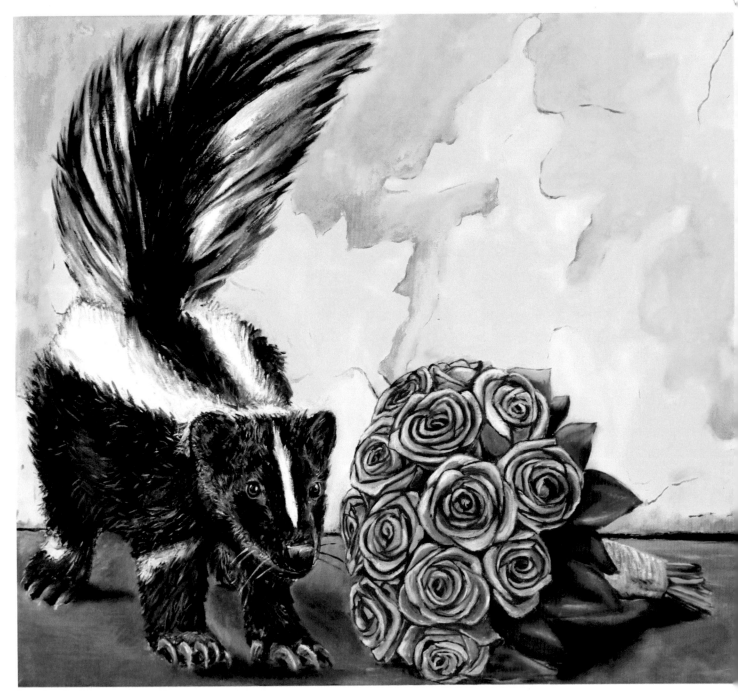

F is for fabulously fragrant

skunk

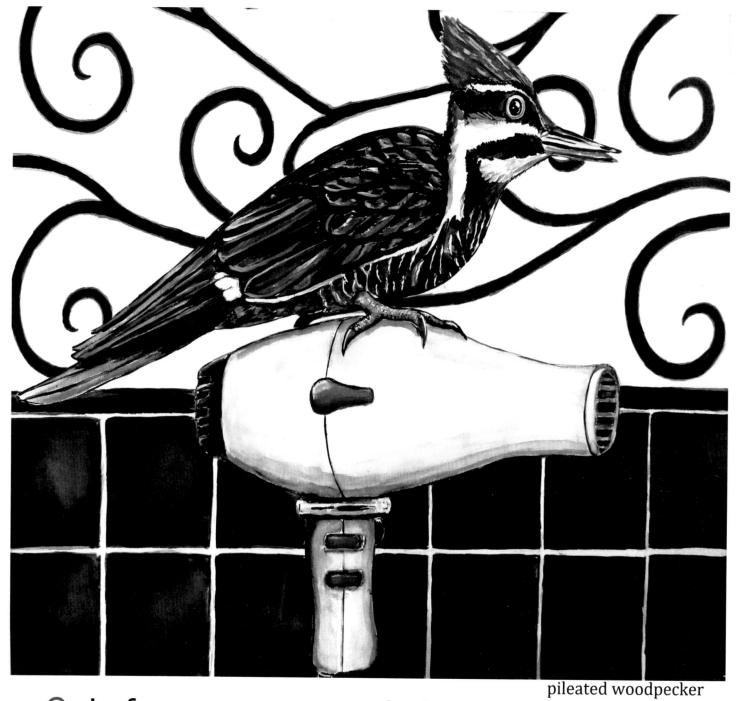

pileated woodpecker

G is for gorgeous and glamorous

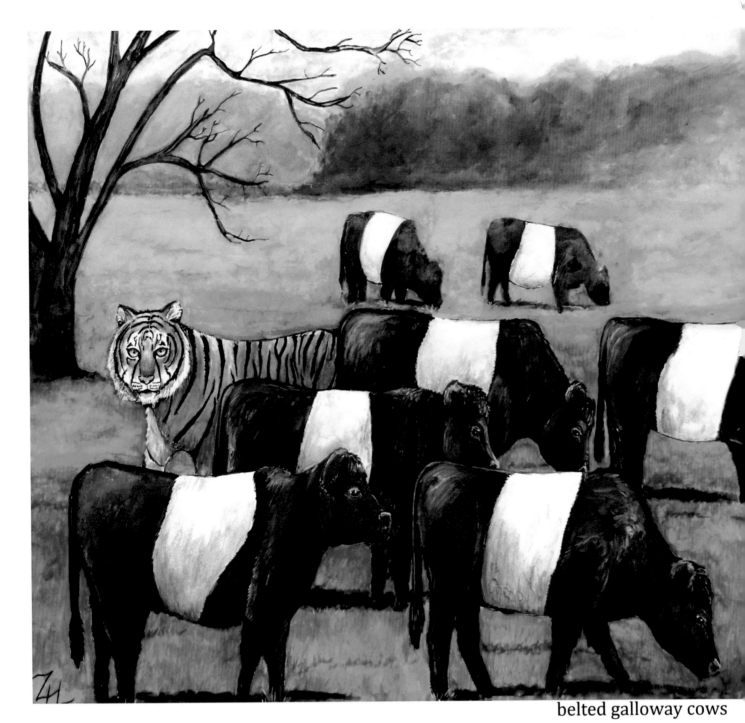

belted galloway cows

H  is for hardly homogenous

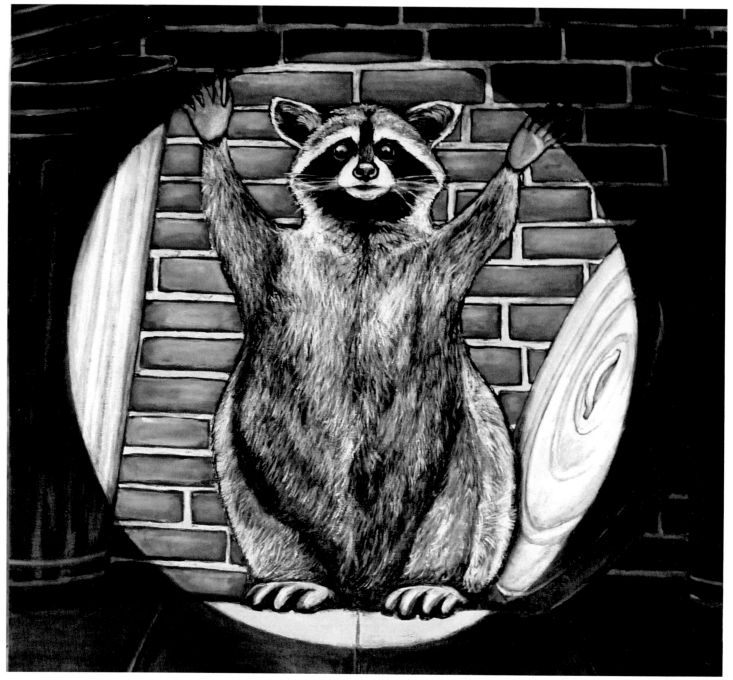

raccoon

I is for illuminated and incriminated

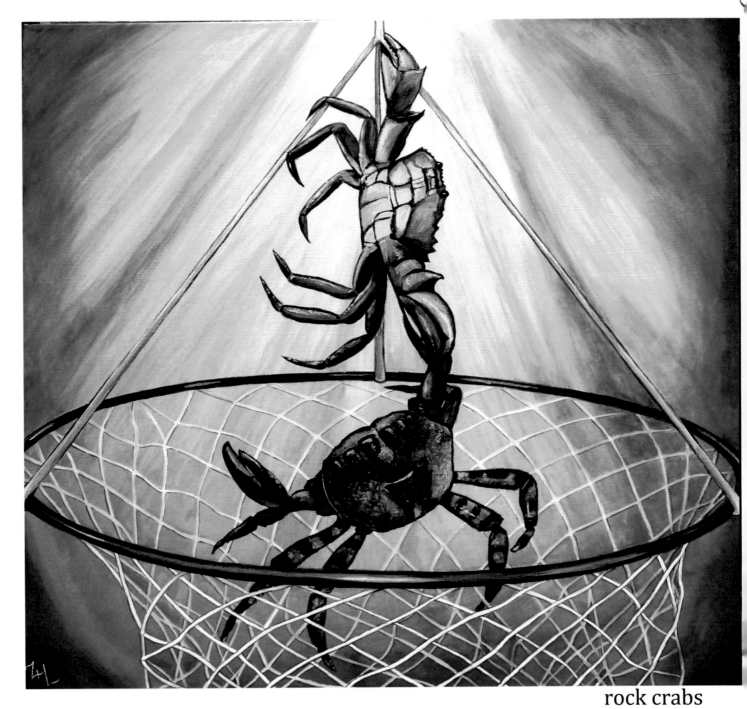

rock crabs

J is for jubilant jailbreakers

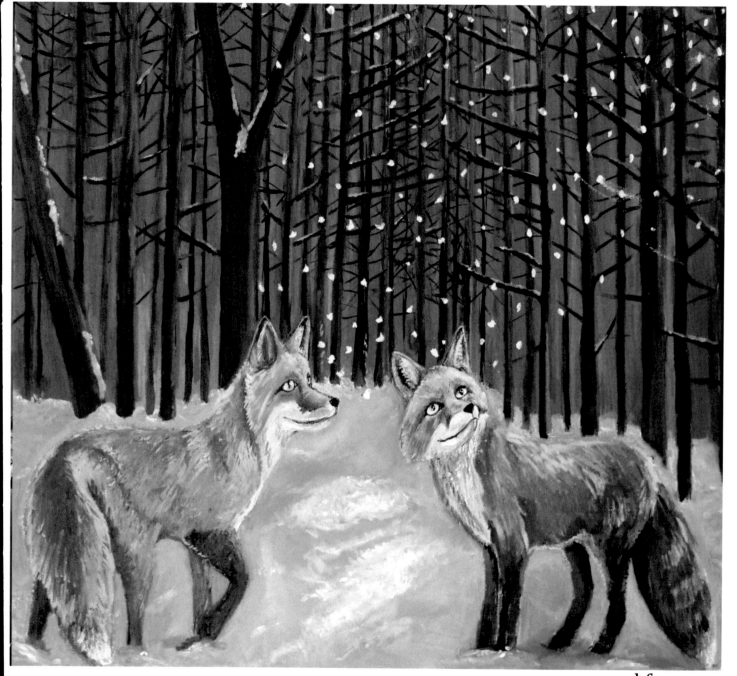

red foxes

K  is for keen kinship

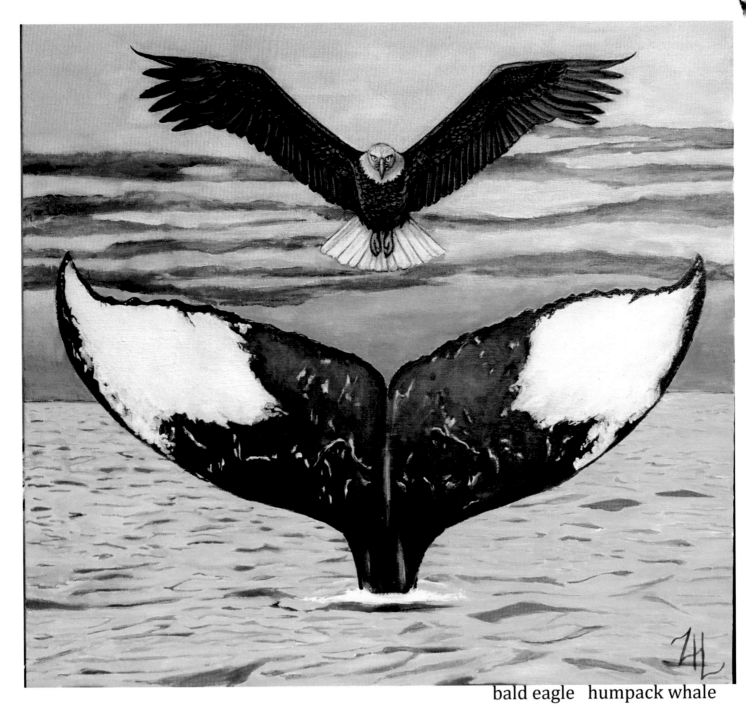

bald eagle   humpack whale

L is for lofty levitation and large leviathan

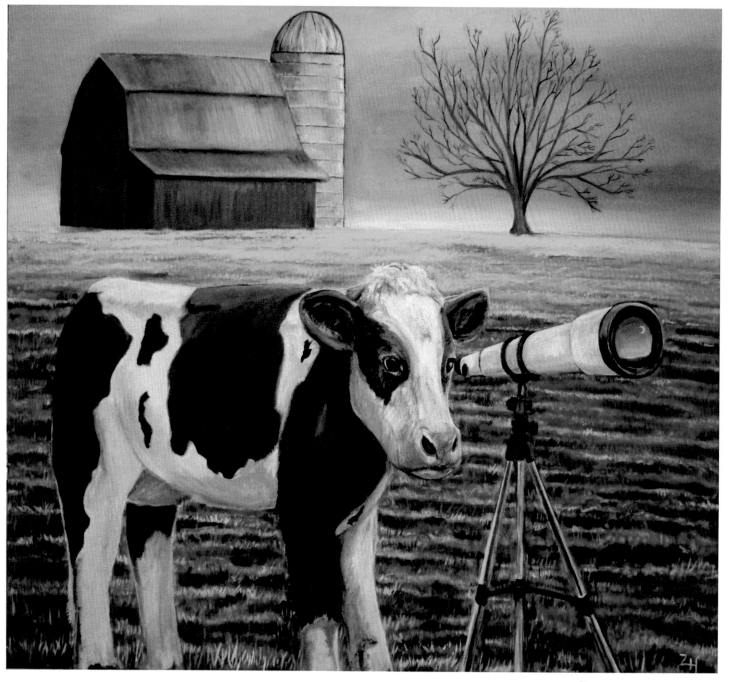

Guernsey cow

M is for mooing moongazer

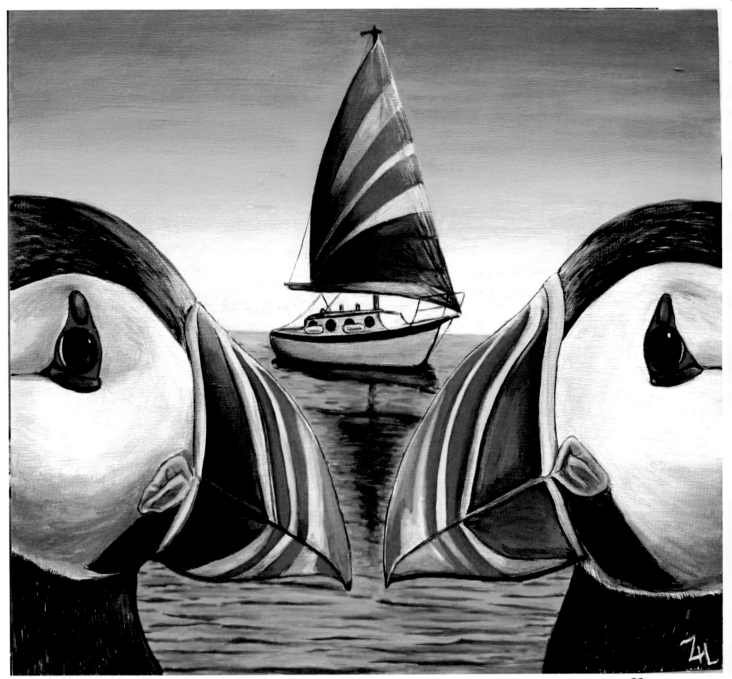

puffins

N  is for nautical noses

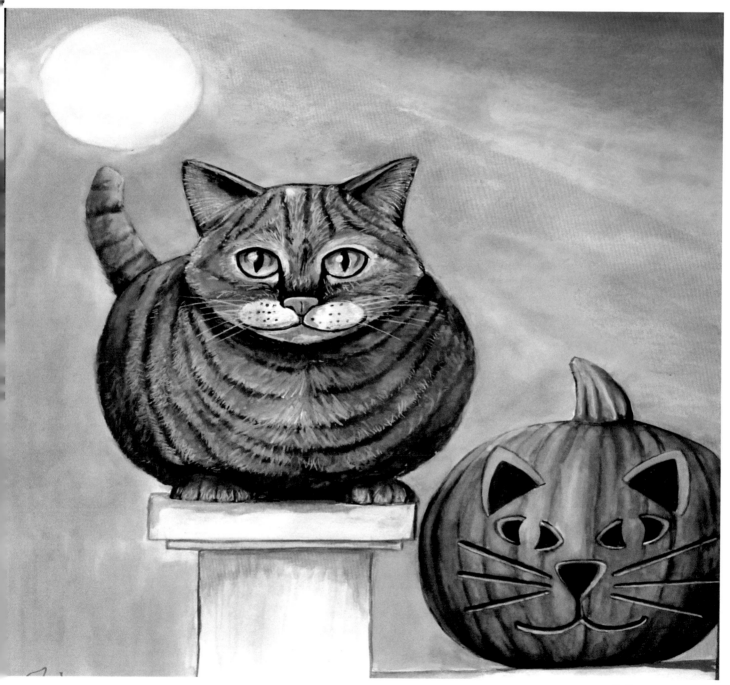

O is for orange October

tabby cat

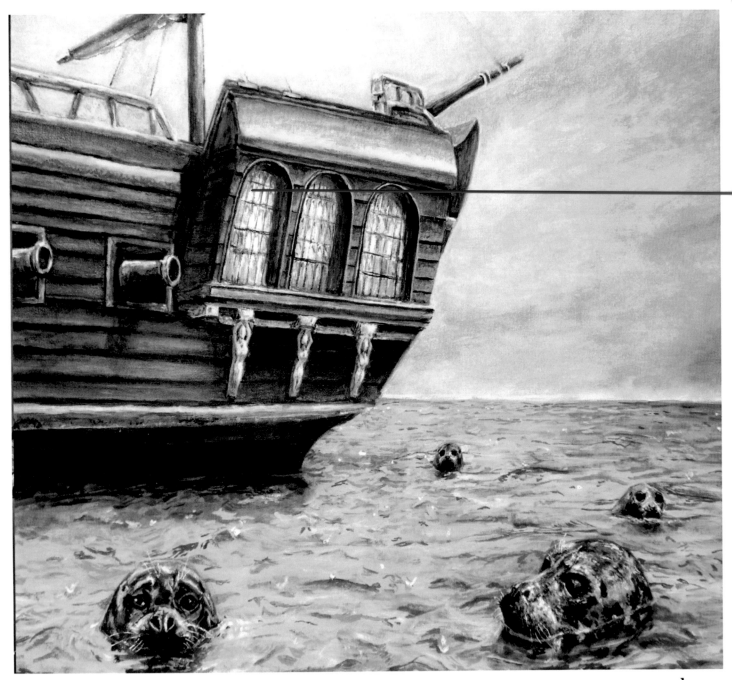

seals

P  is for peeking pirate pups

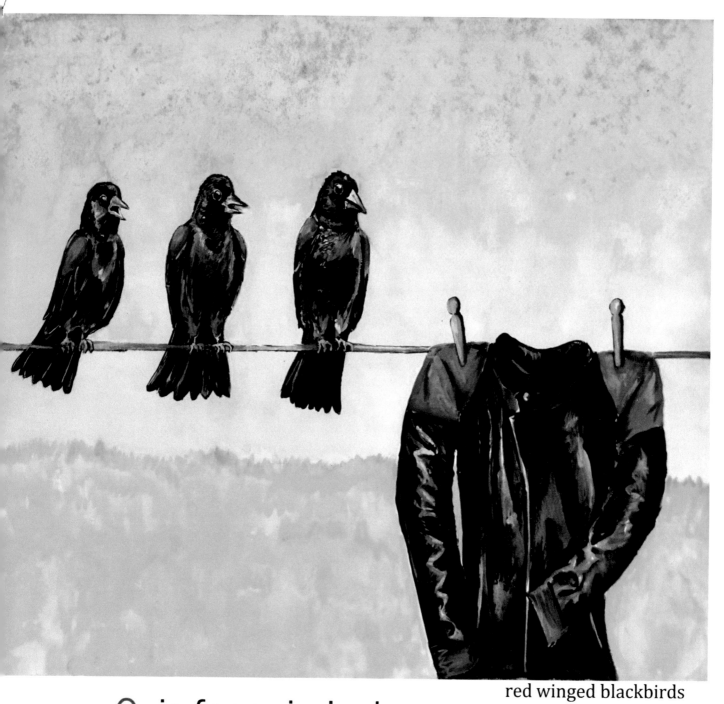

red winged blackbirds

Q  is for quizzical queue

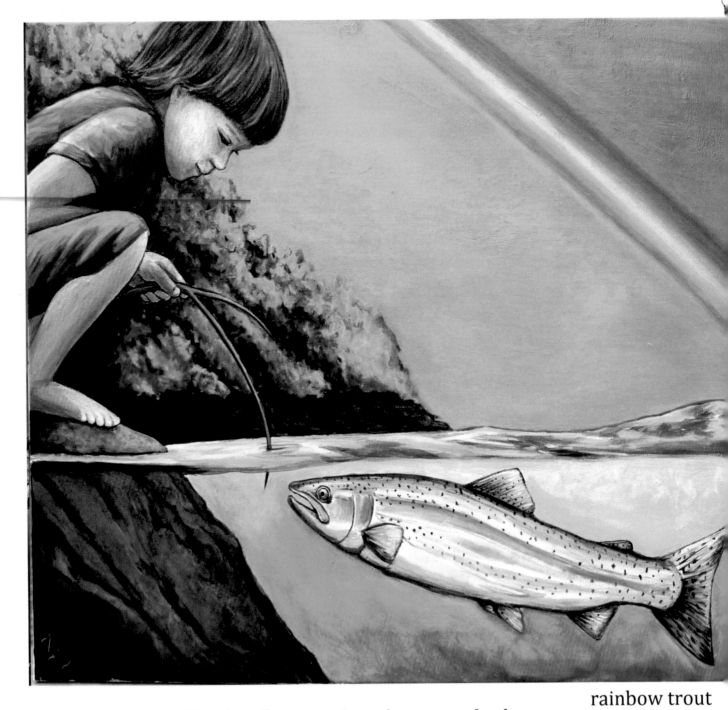

rainbow trout

R  is for relaxing rainbow

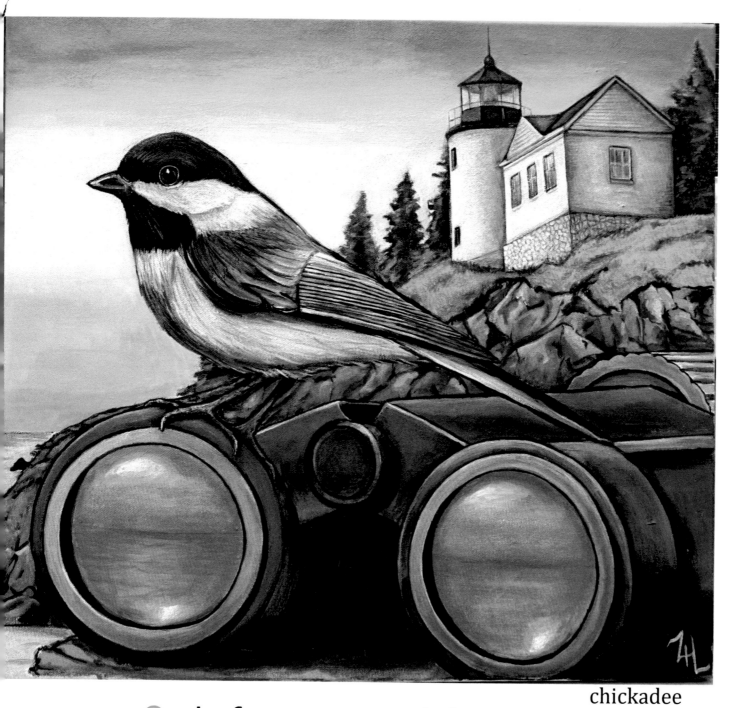

chickadee

S  is for serene sightseer

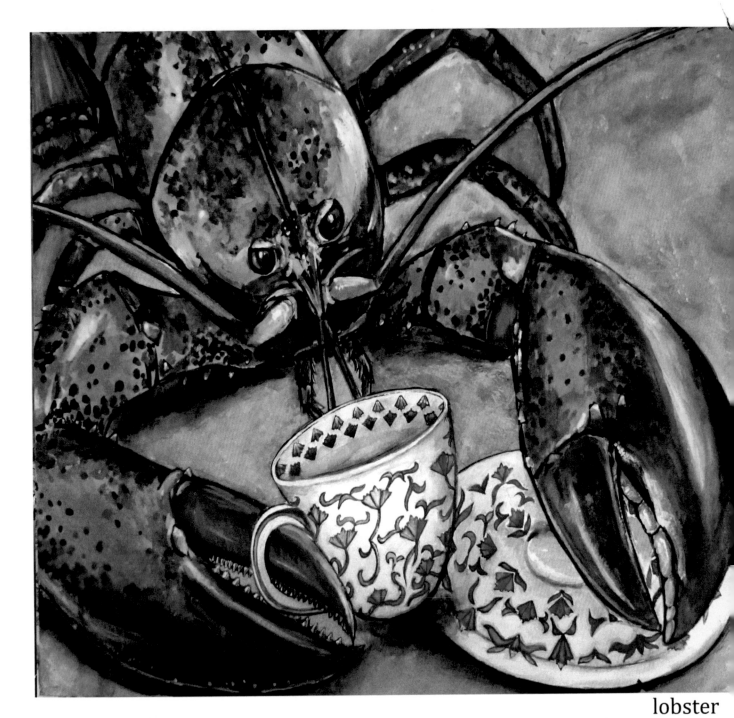

lobster

T is for teetotaling terrible tickler

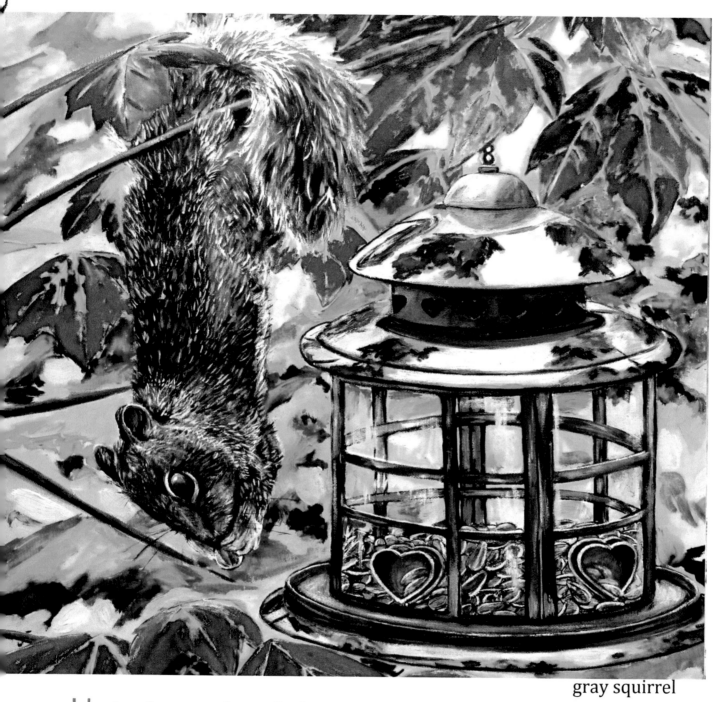

gray squirrel

U is for unlawful and upside-down

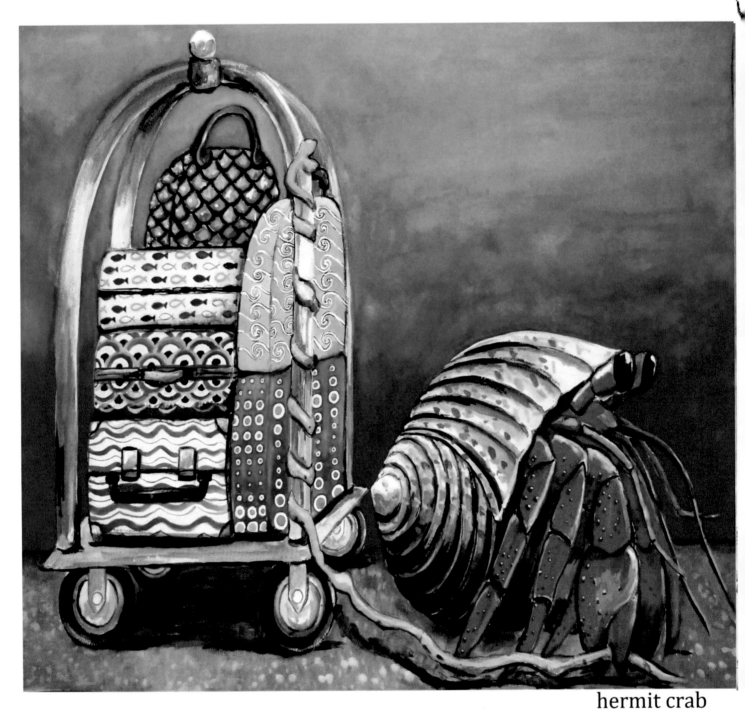

hermit crab

V is for vacationing vagabond

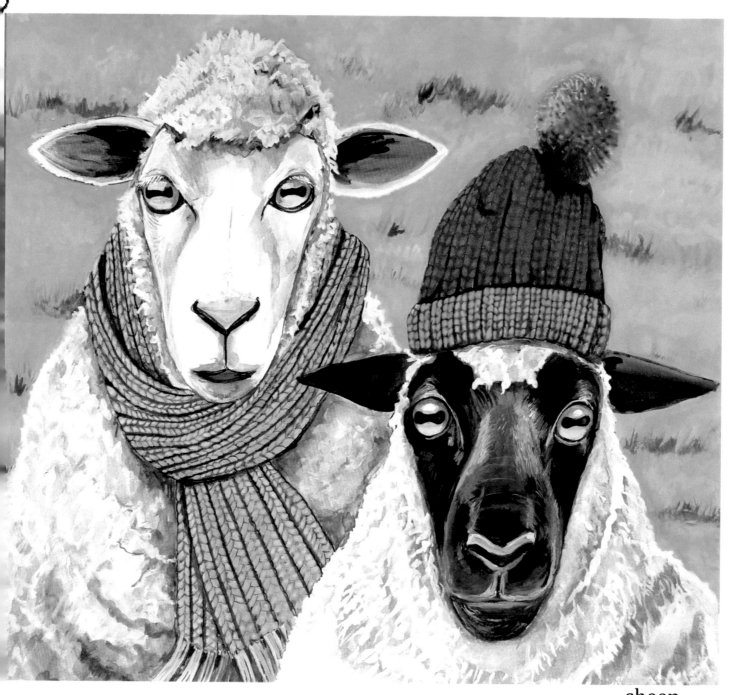

sheep

W is for warm and woolly

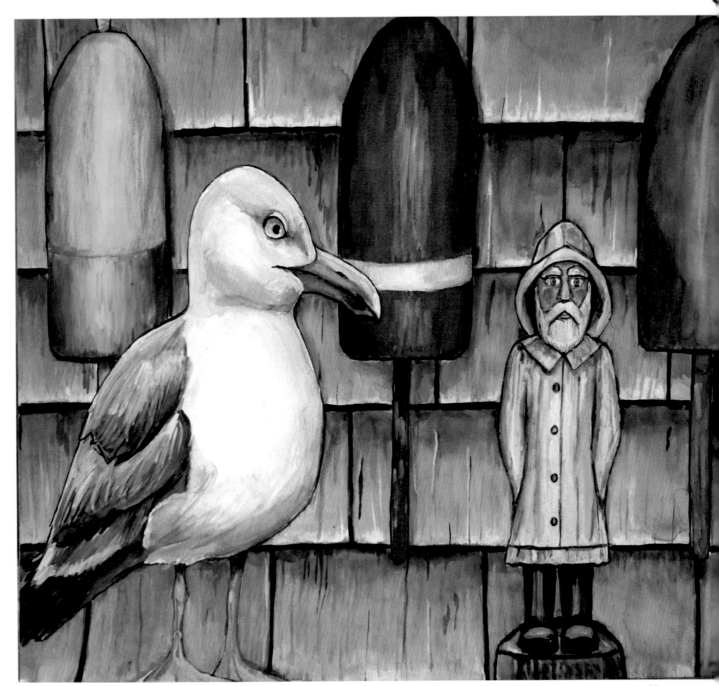

gull

X is for coexisting

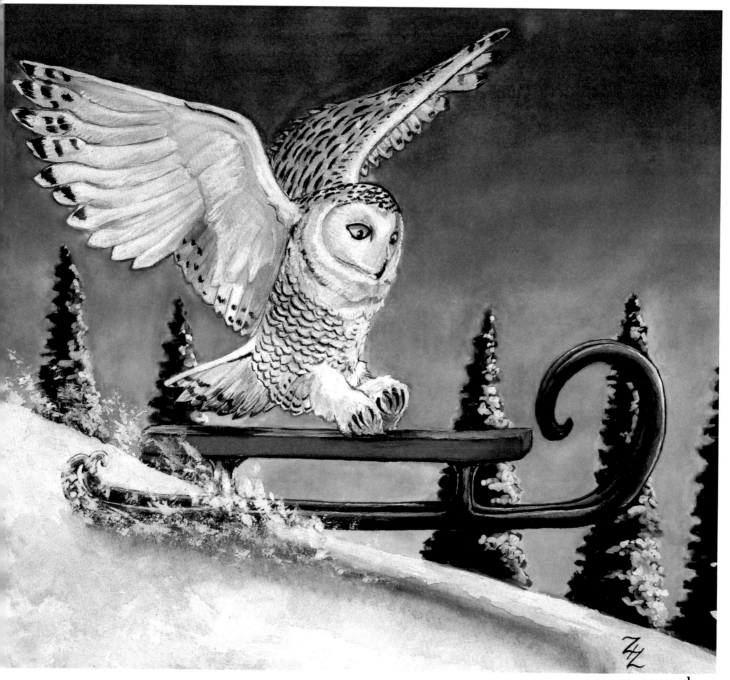

snowy owl

Y is for Yippee! Yahoo!

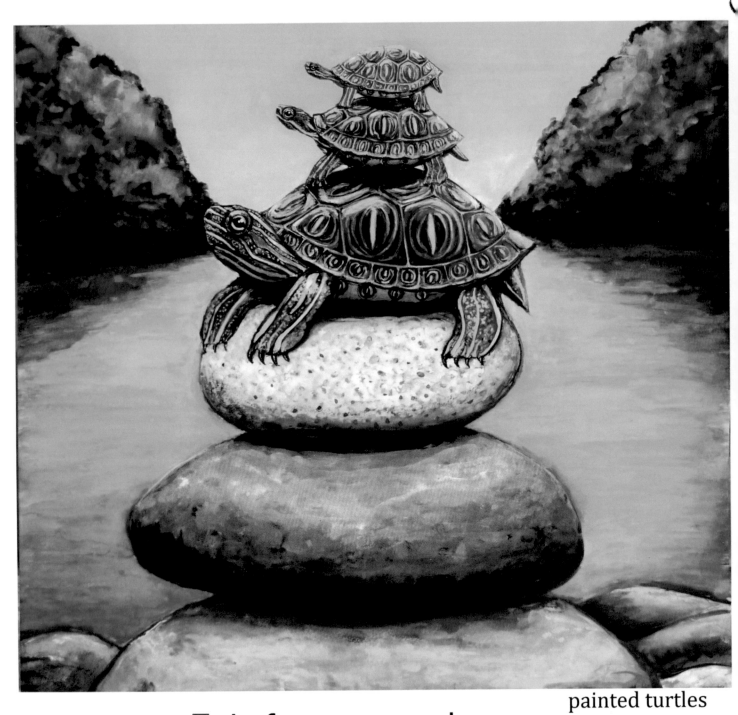

painted turtles

Z is for zany and zen

Made in the USA
Lexington, KY
17 April 2018